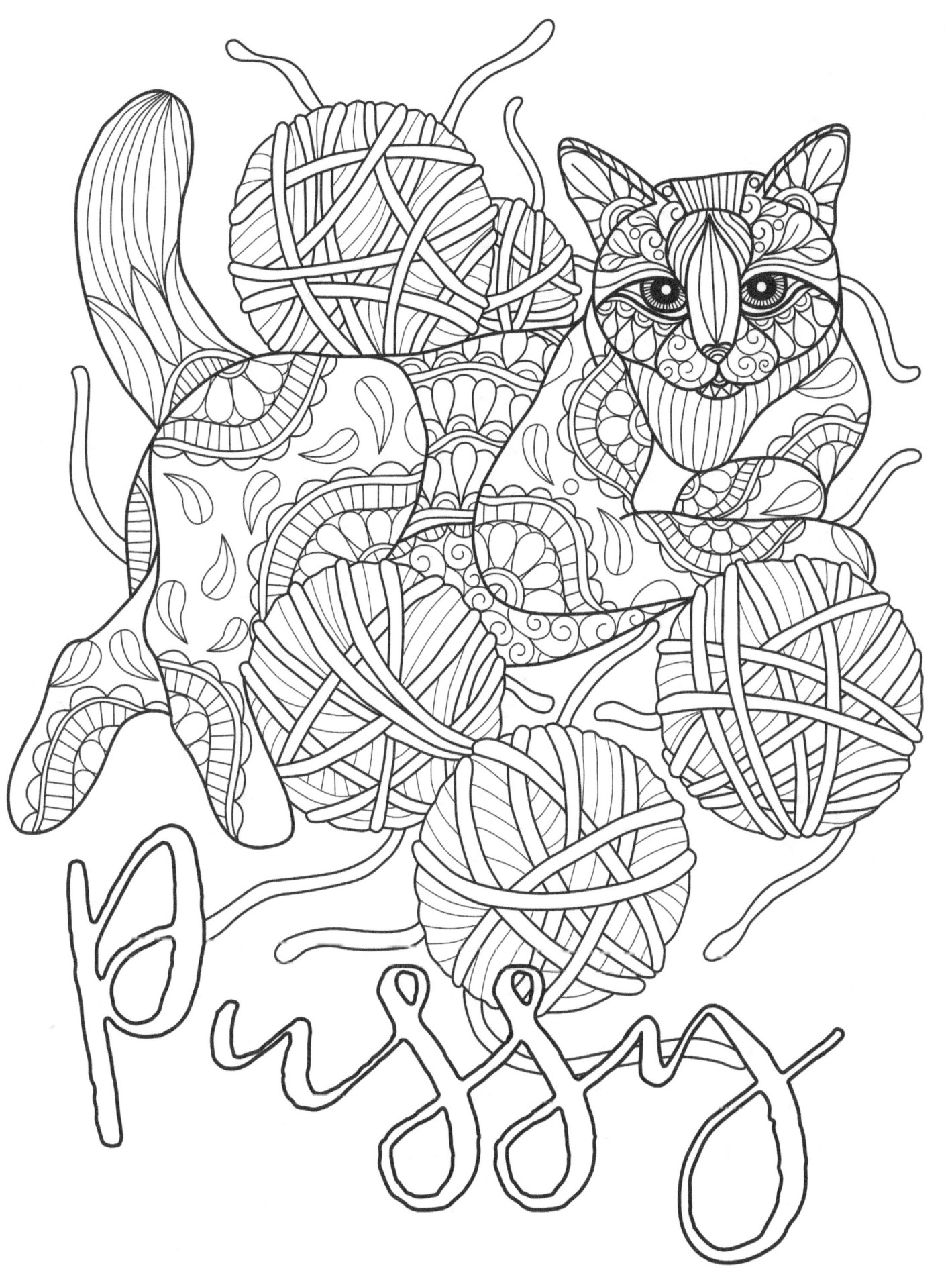

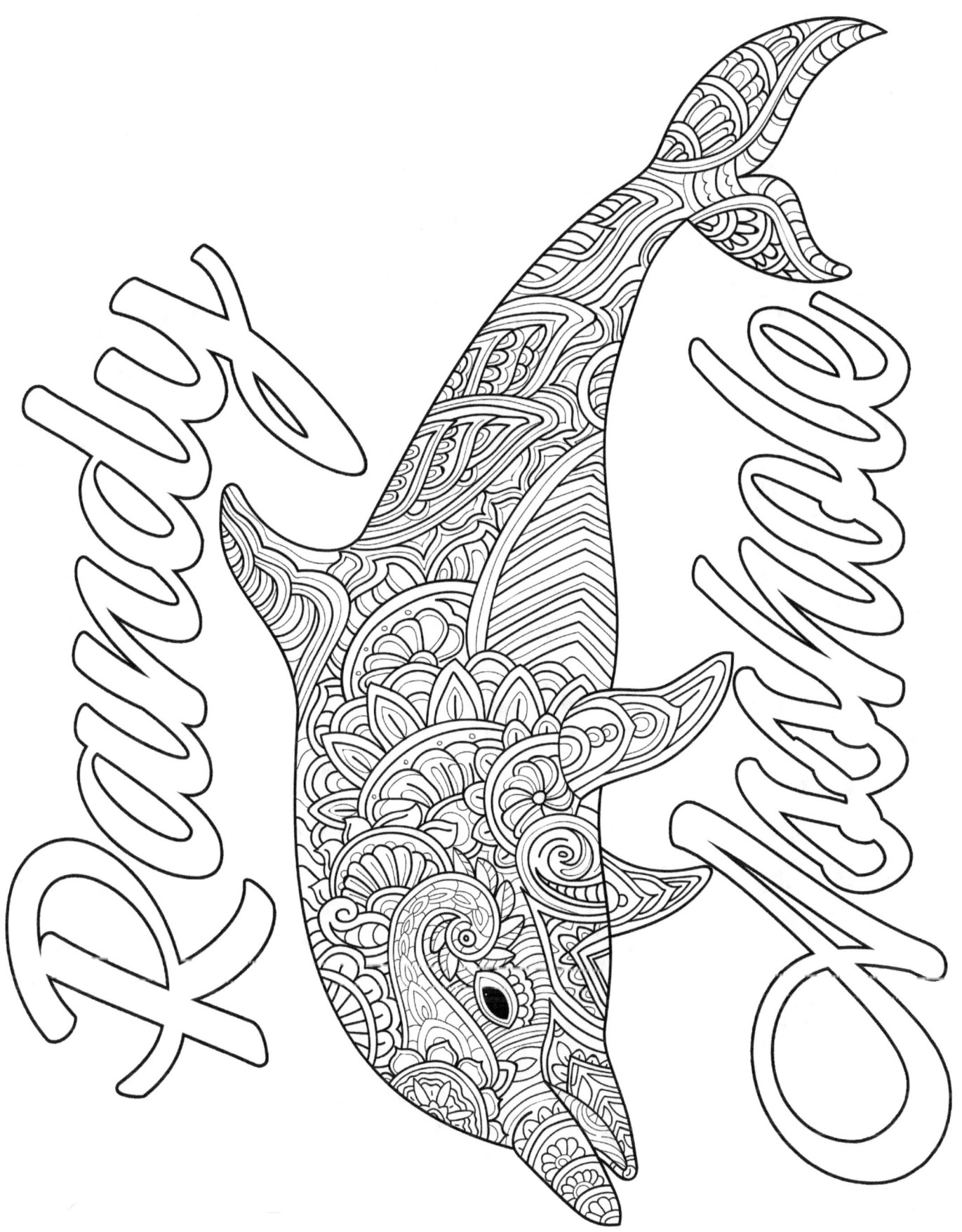

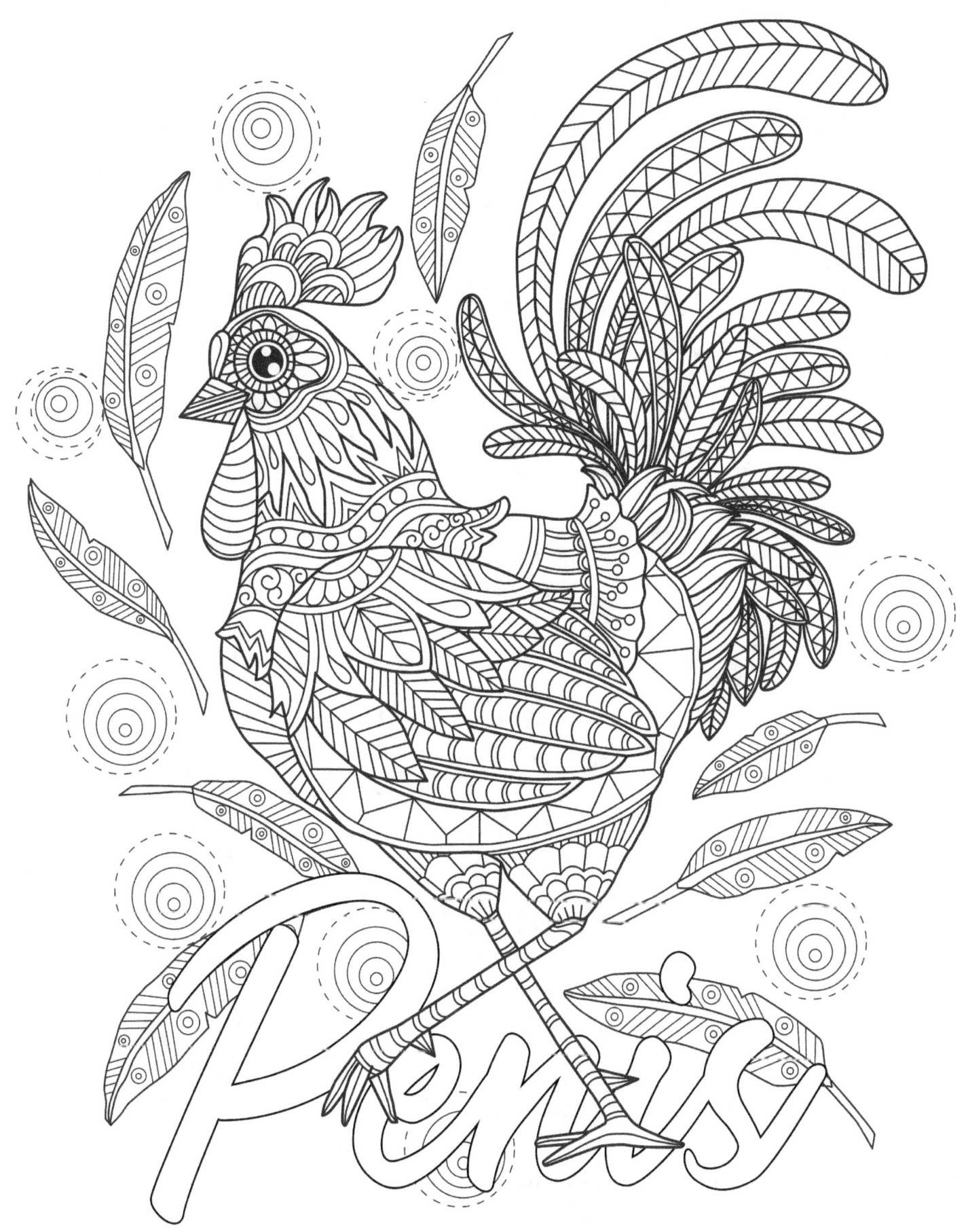

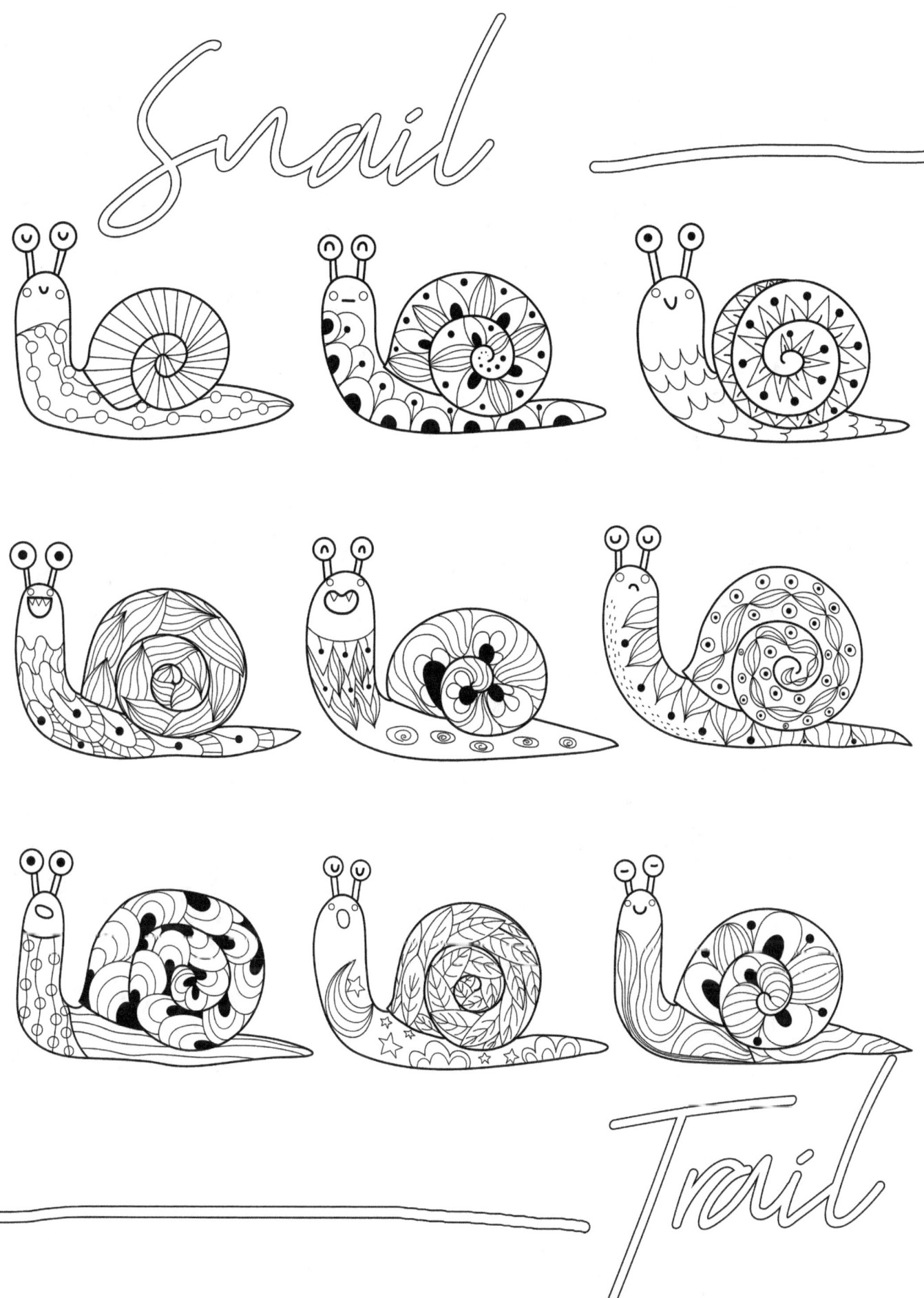

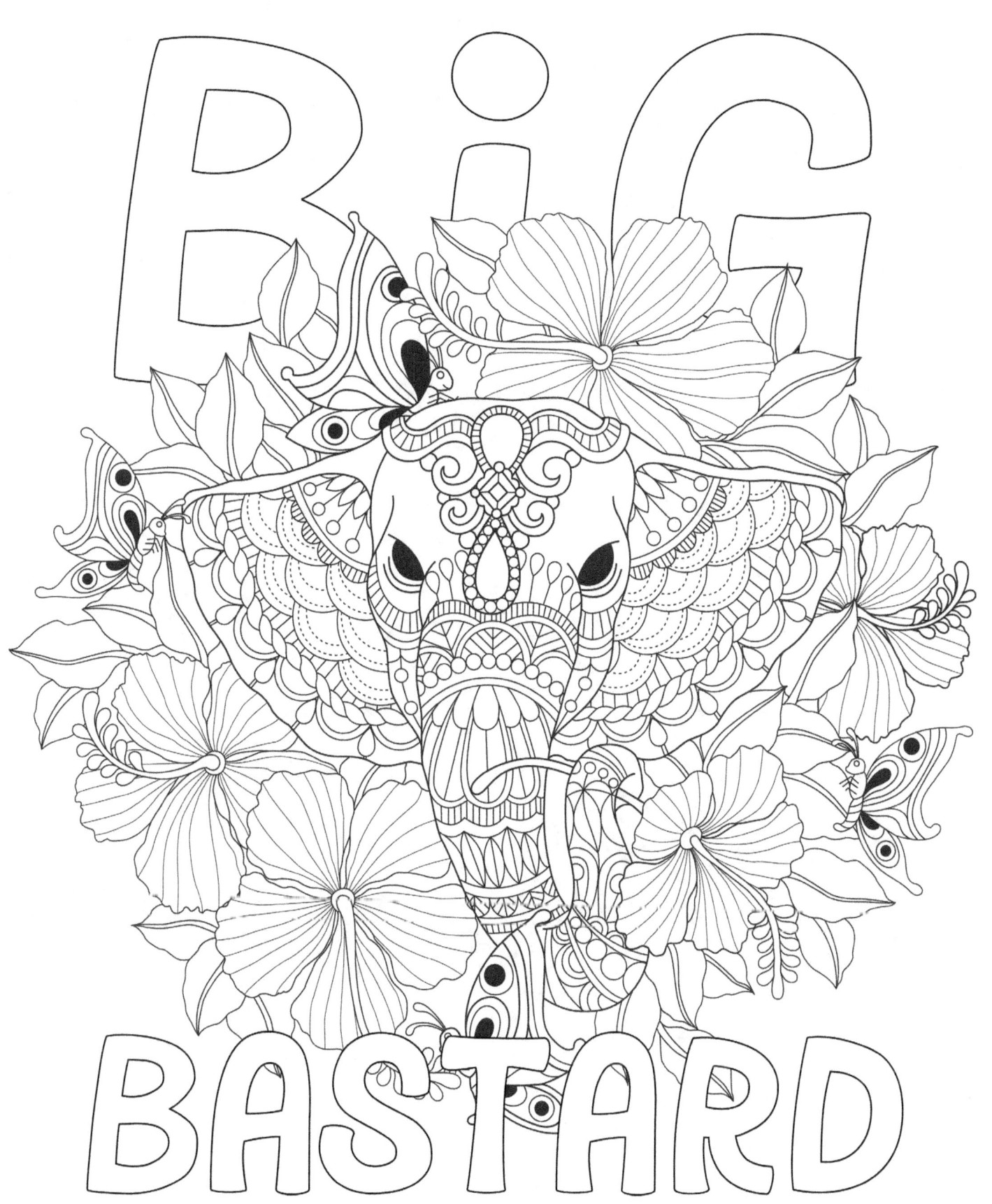

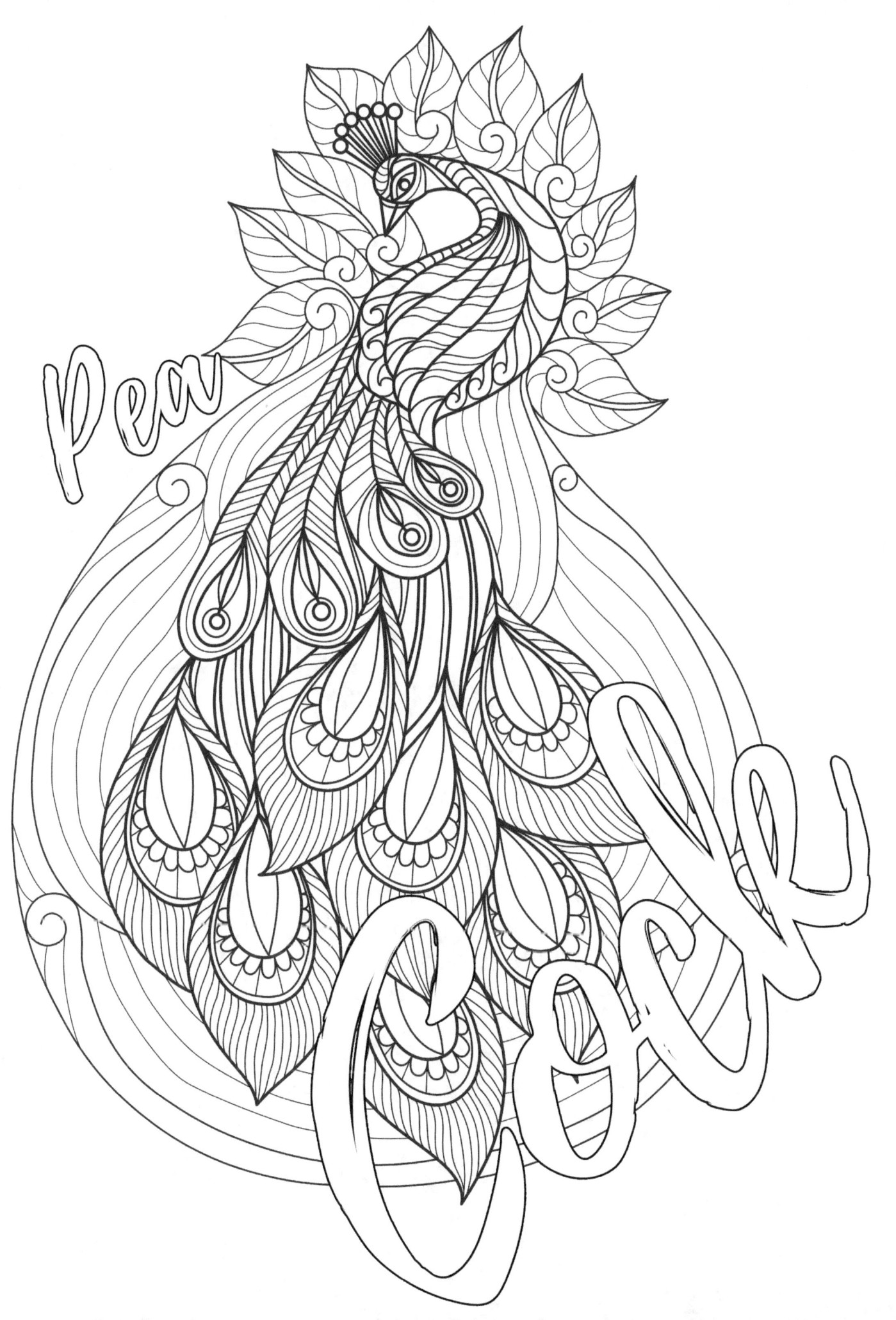

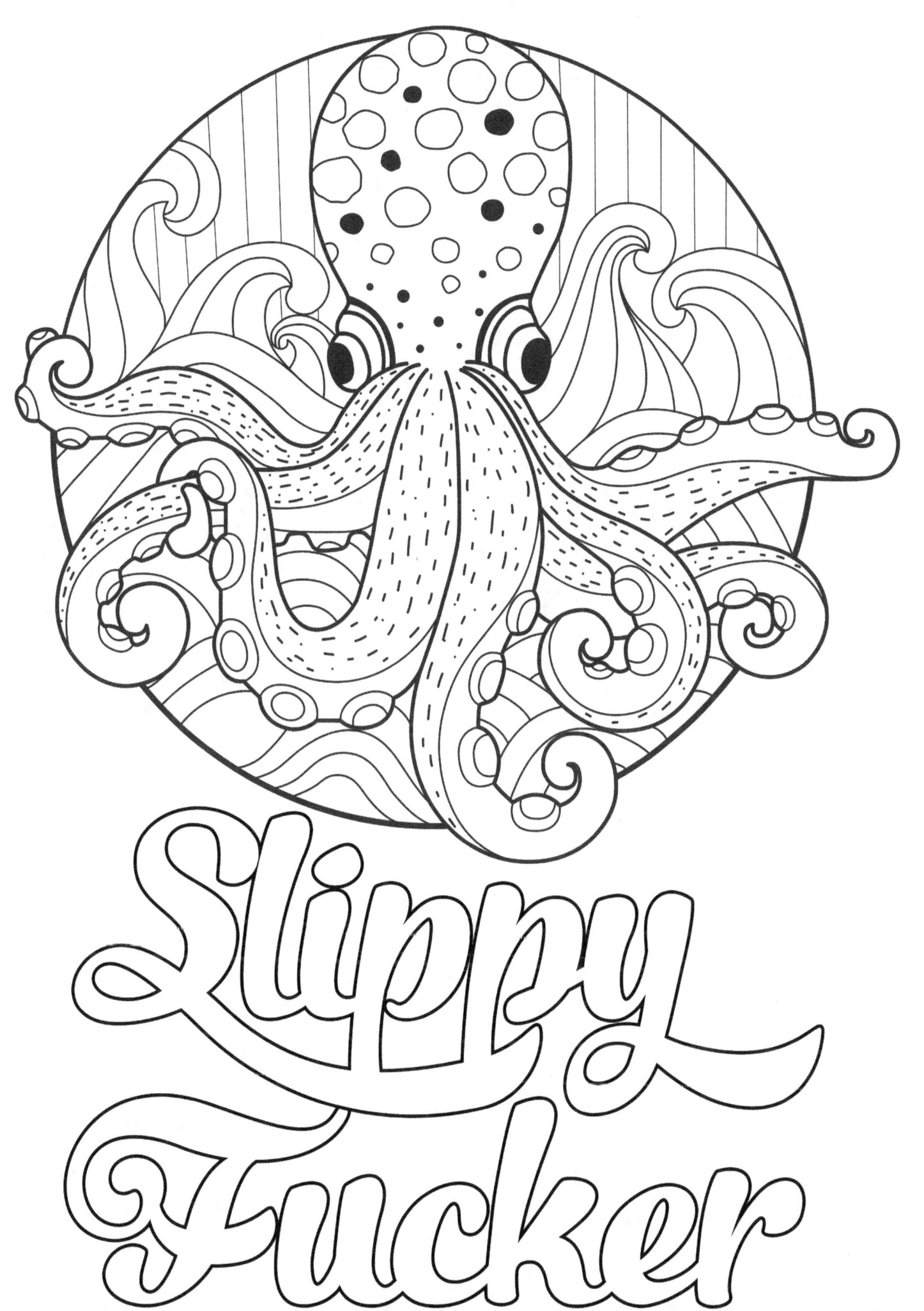

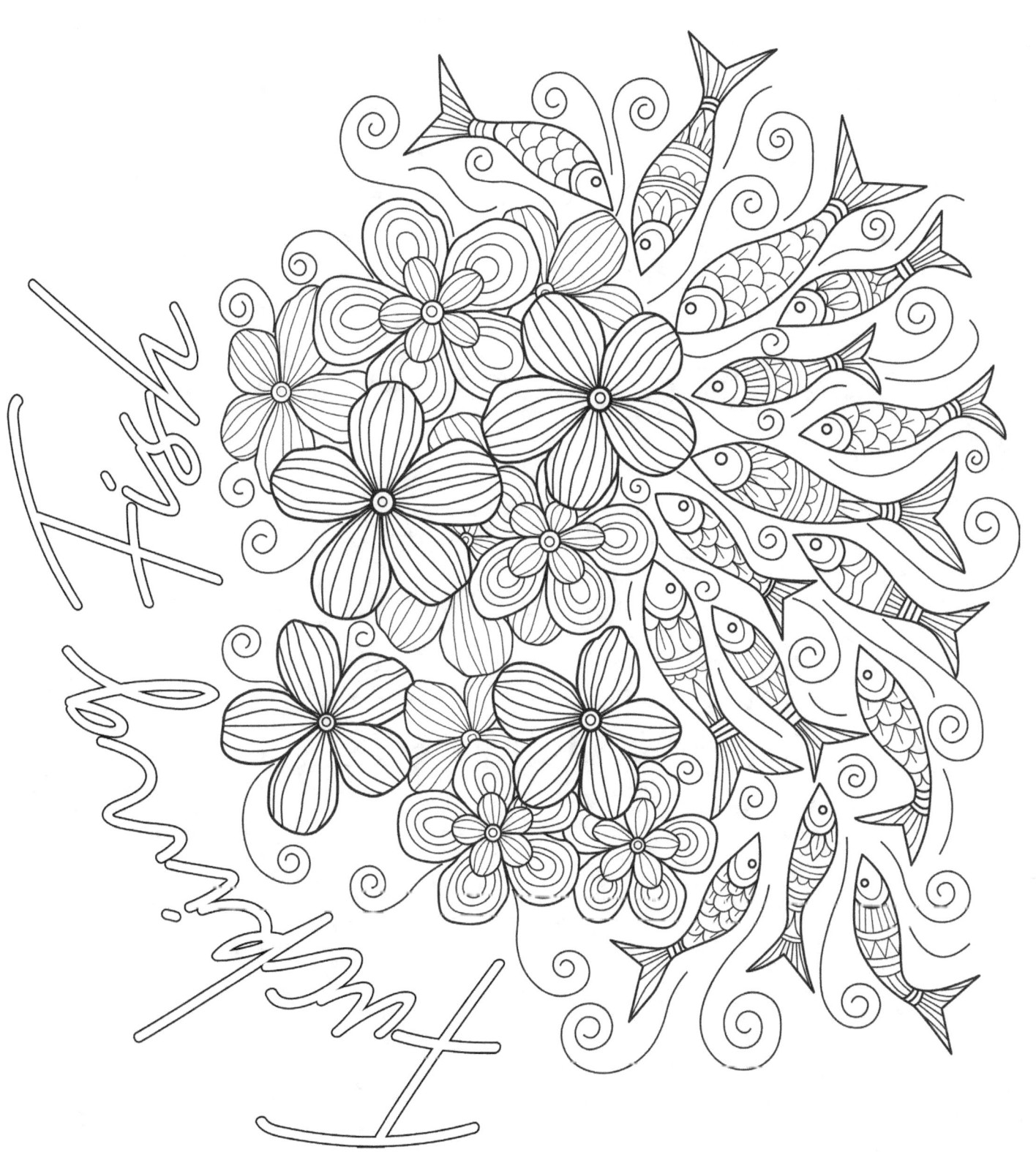

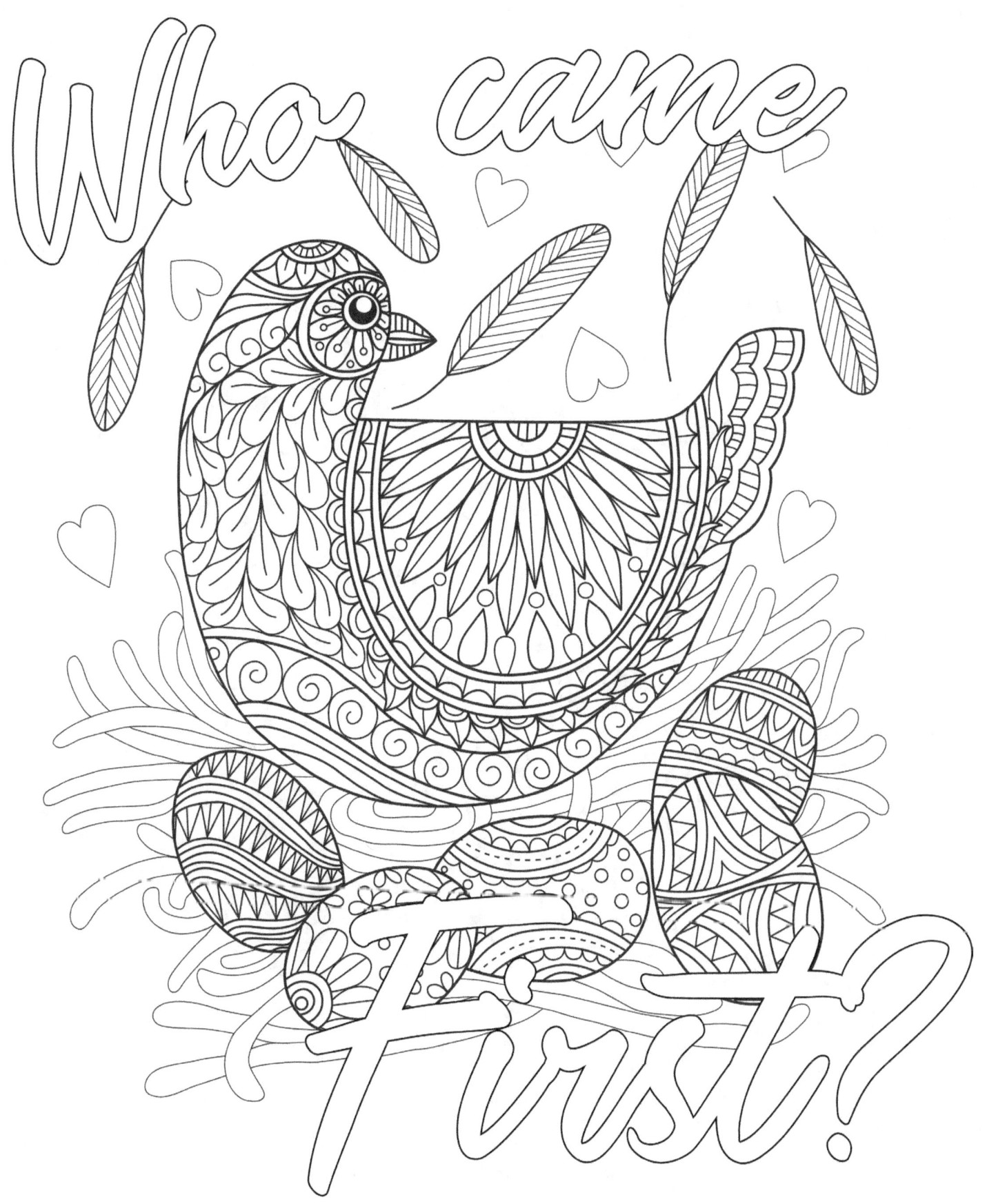

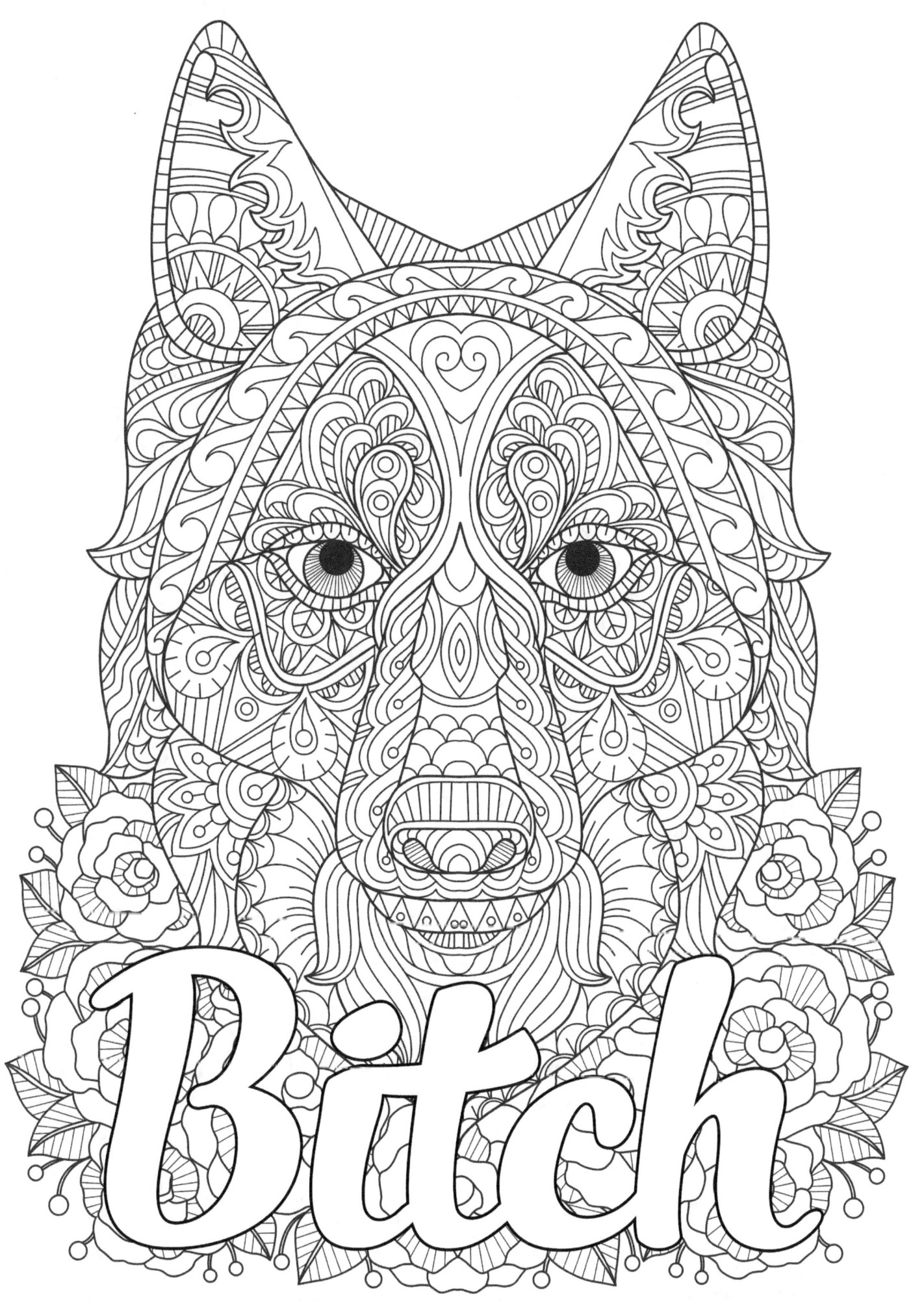

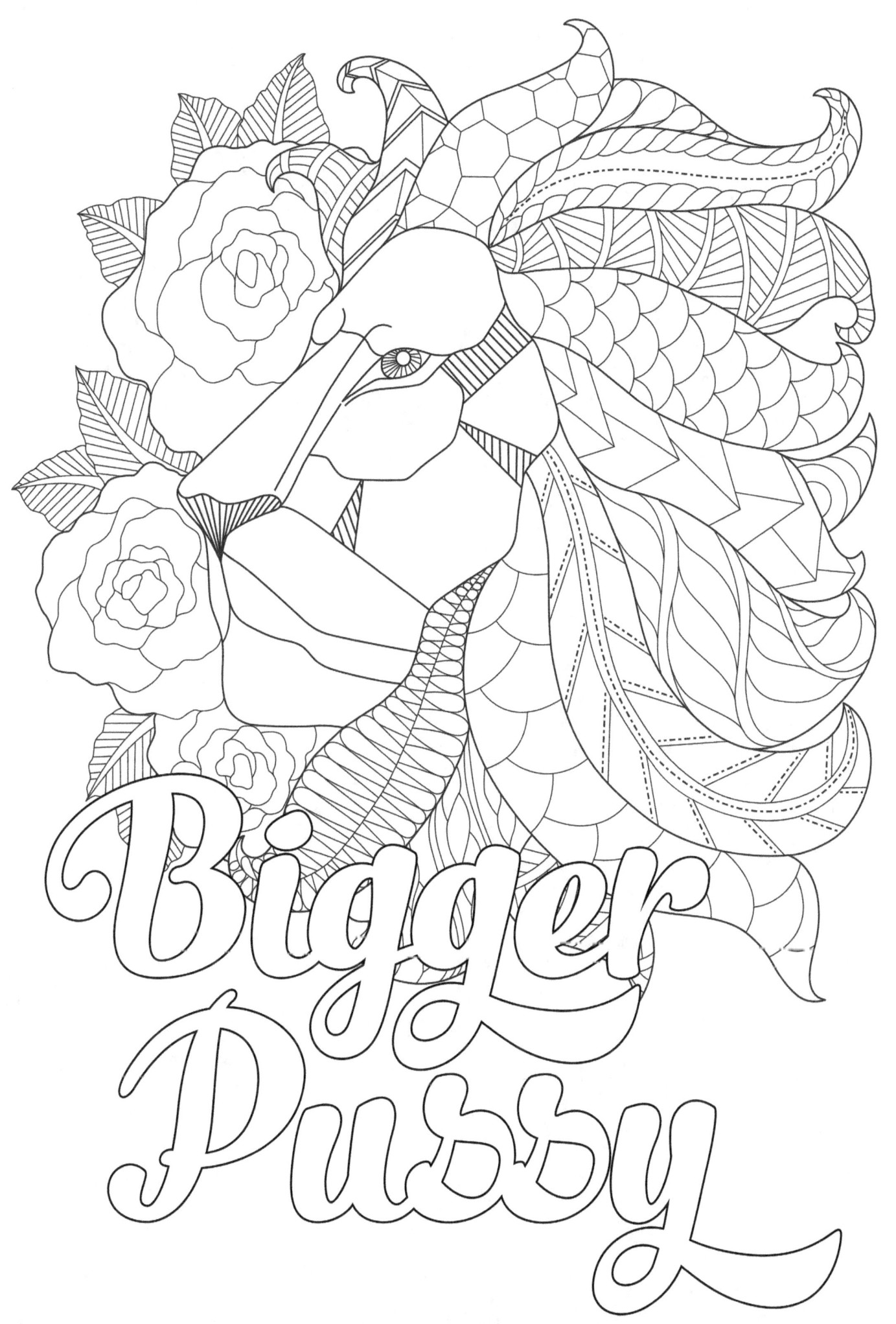

Open up Your Butterfly

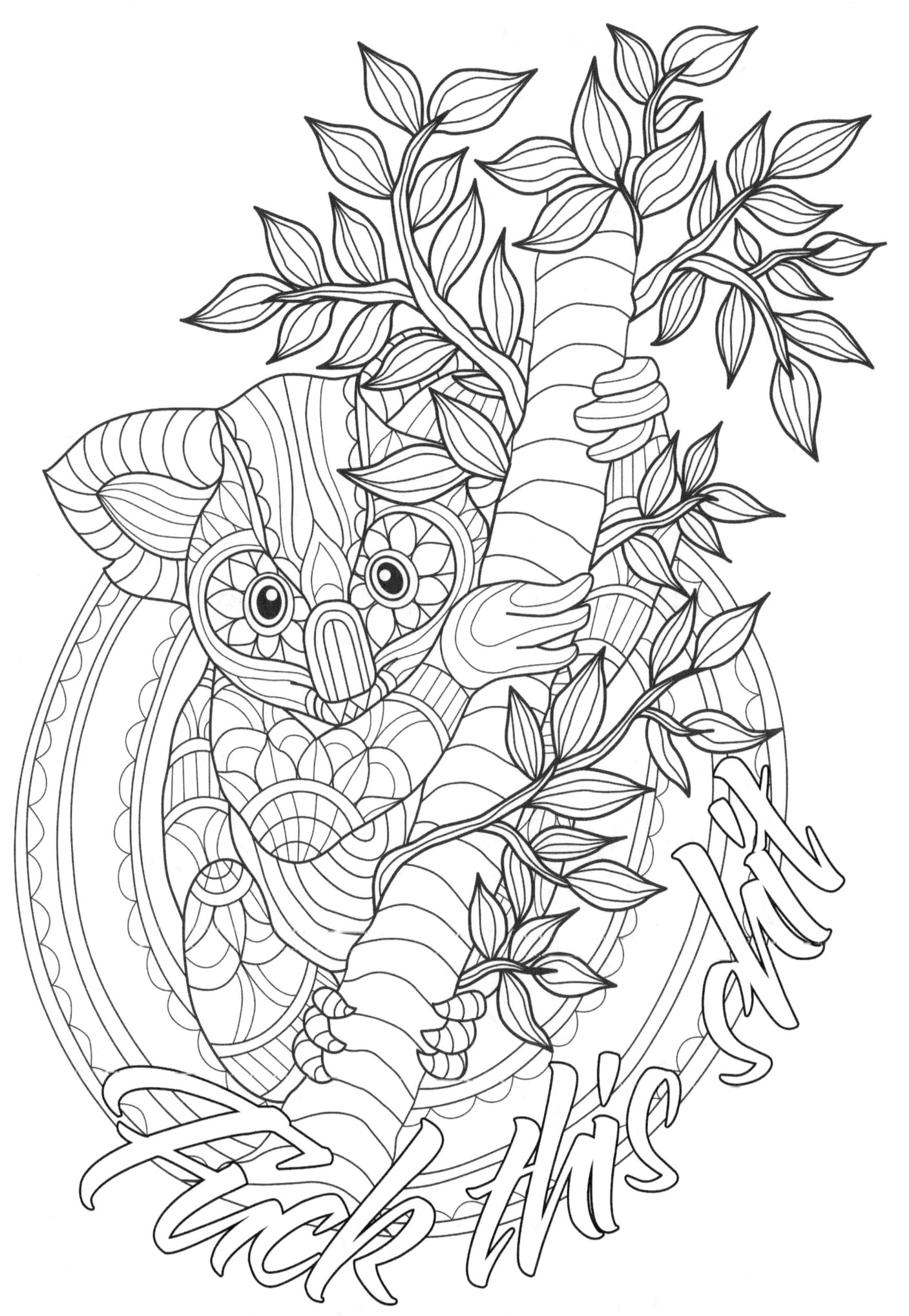

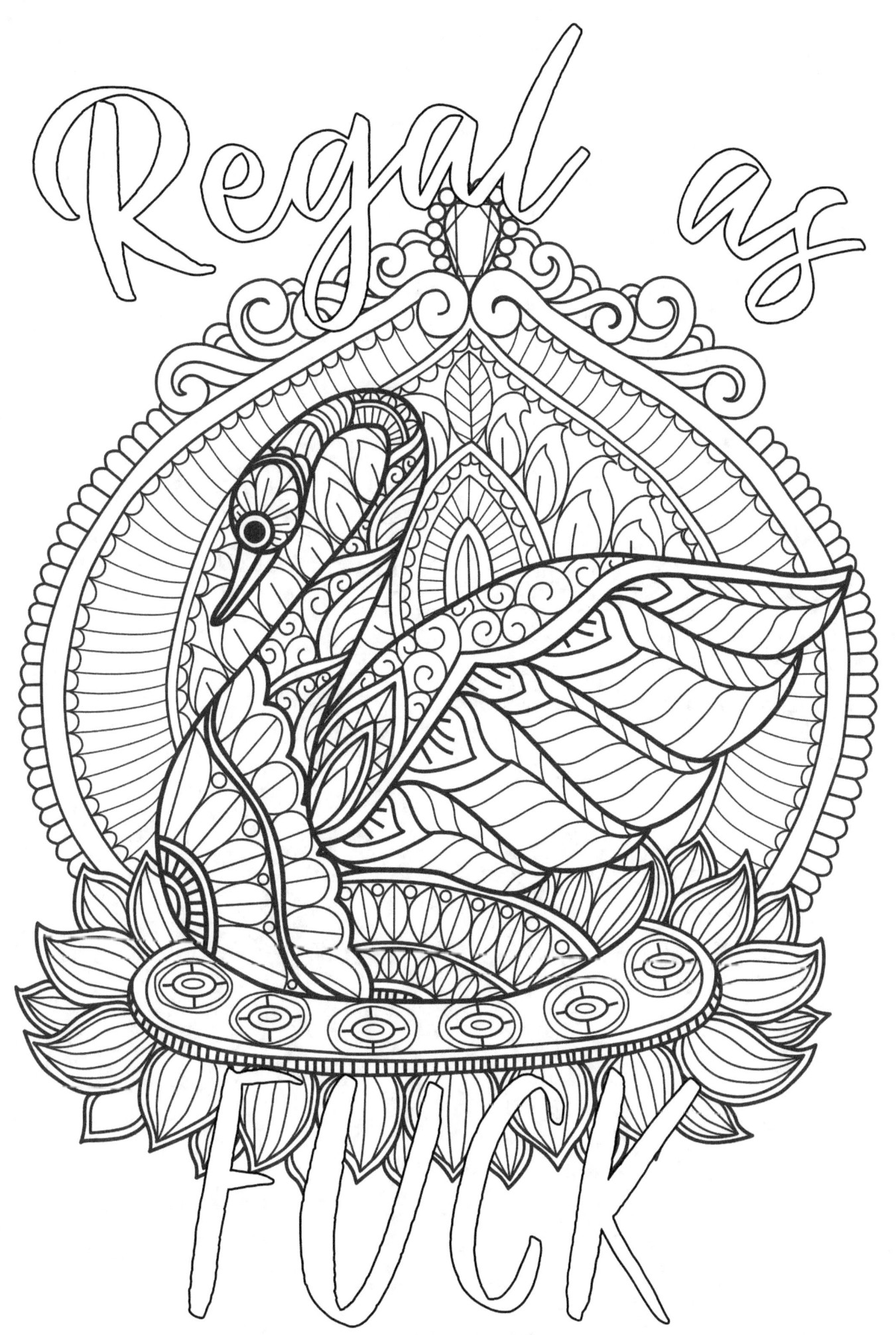

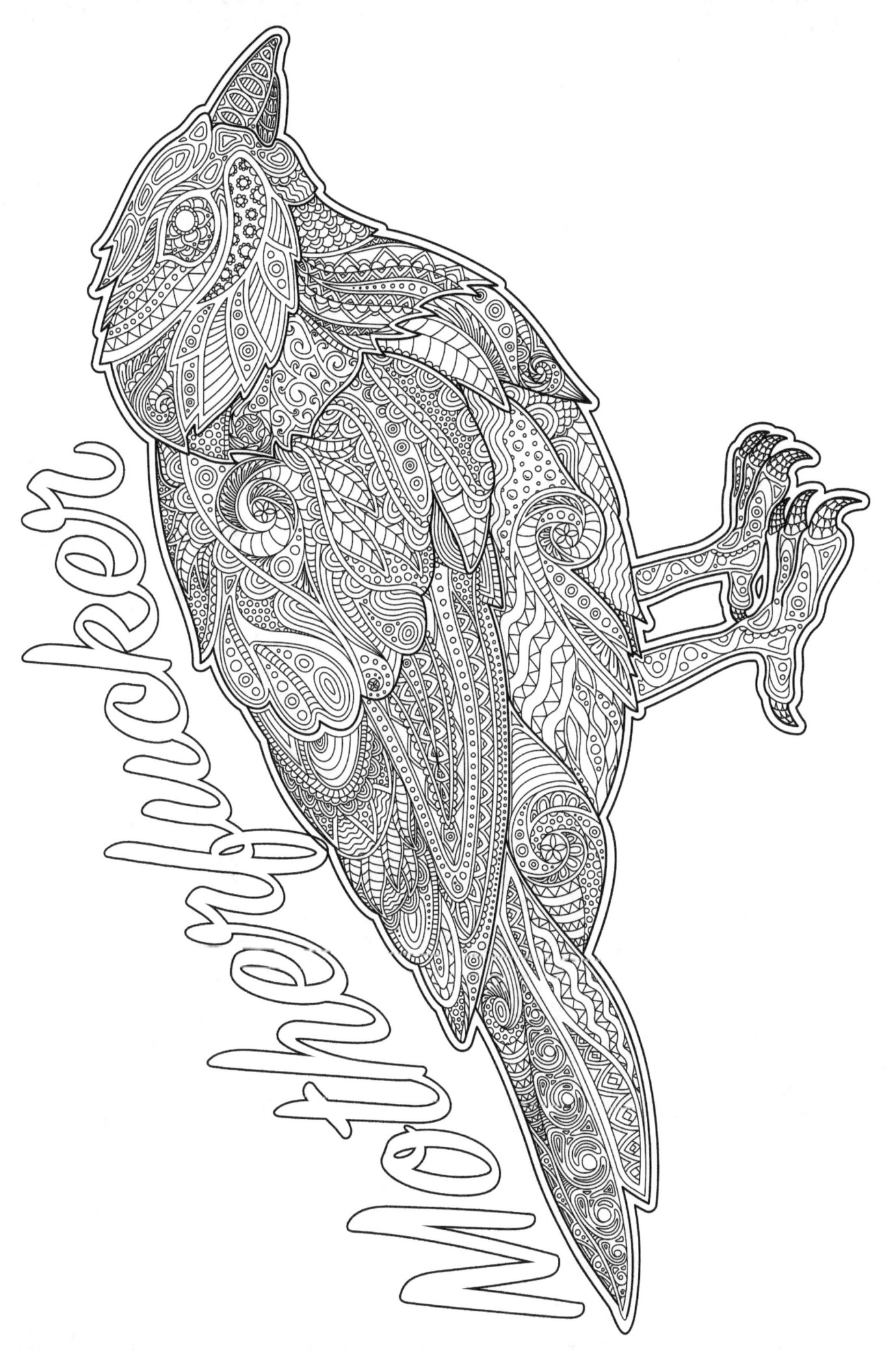

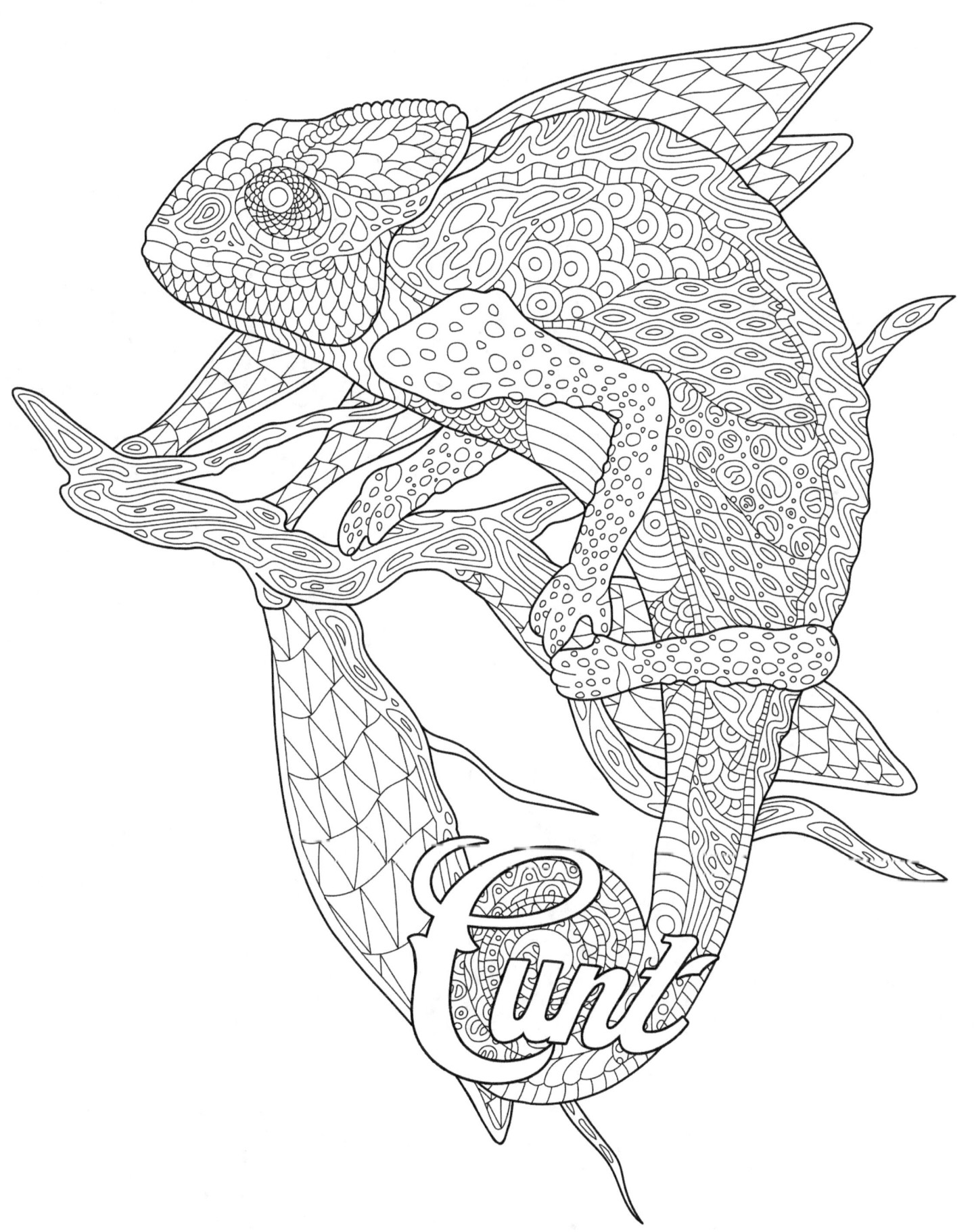

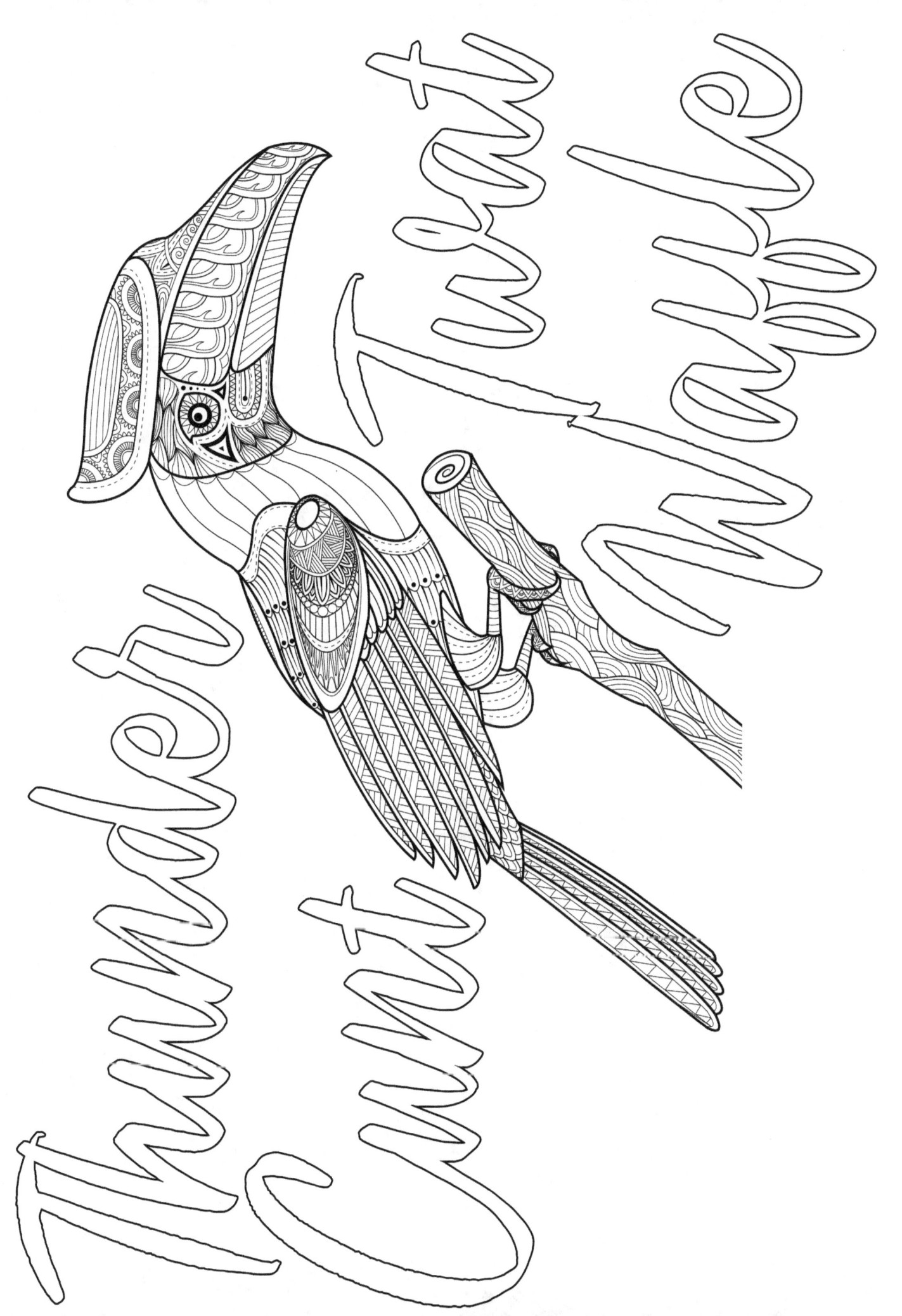

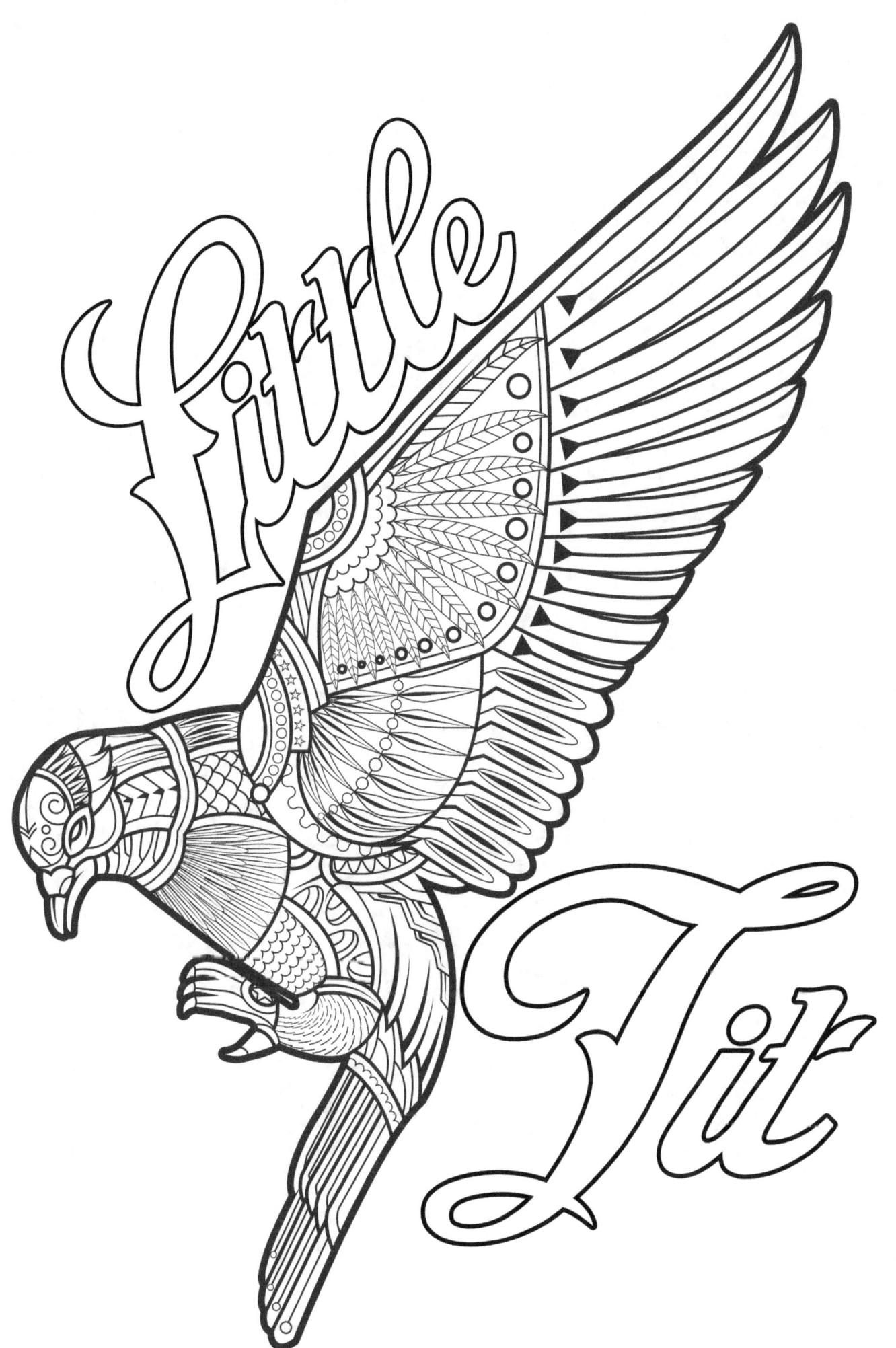

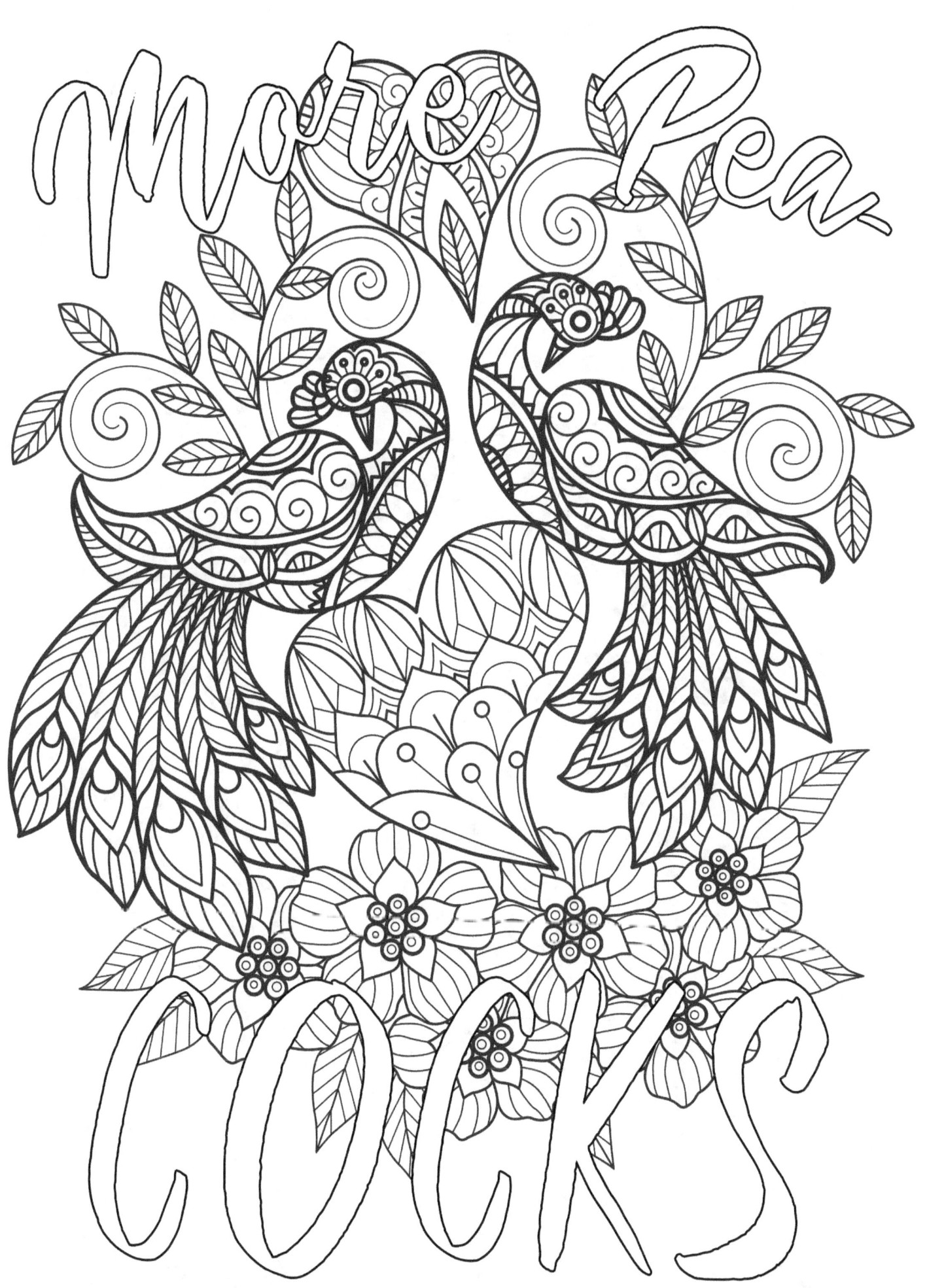

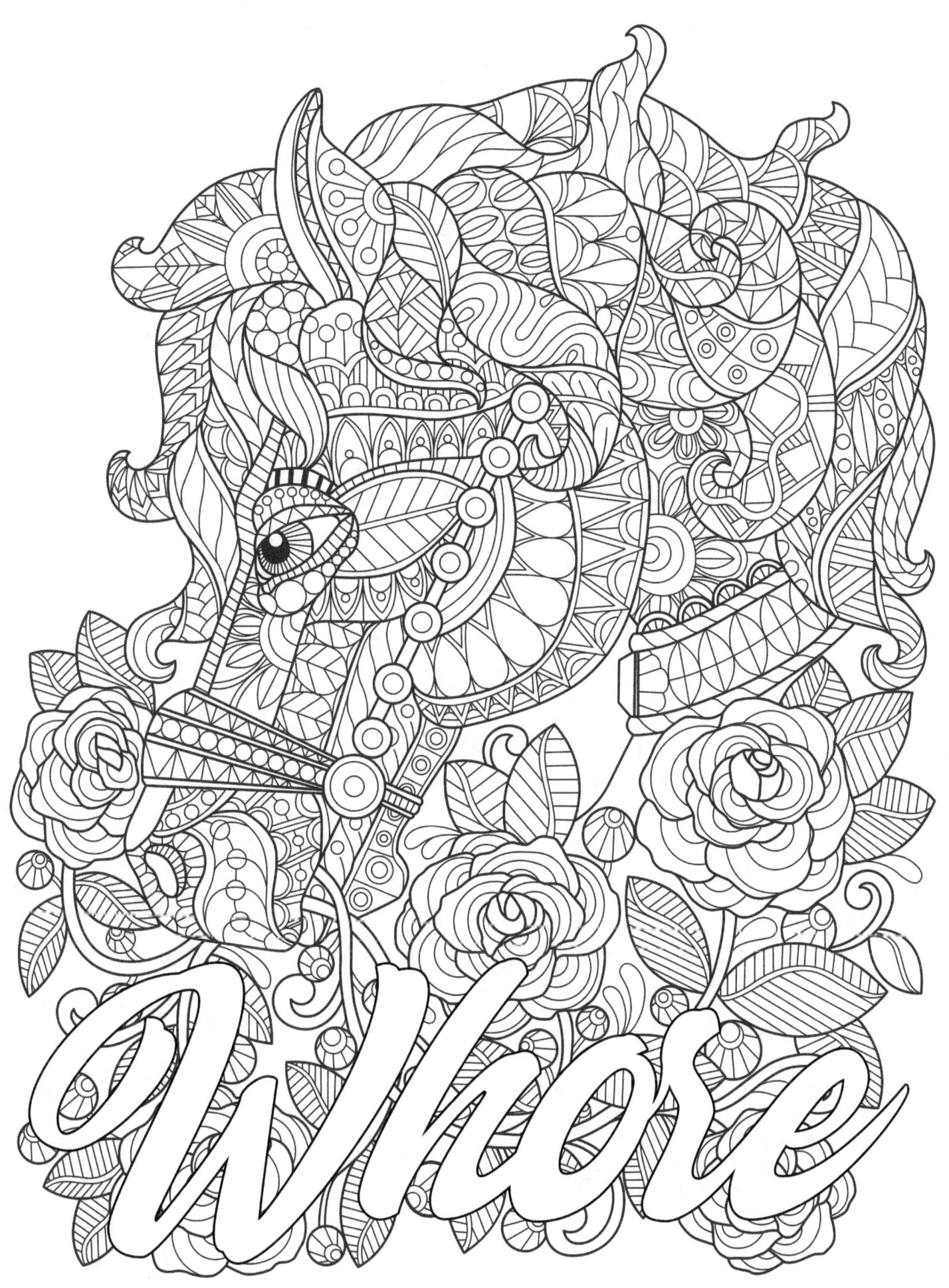